CLASSIC PAPERBACKS NOTEBOOK

PRINCETON ARCHITECTURAL PRESS

NEW YORK

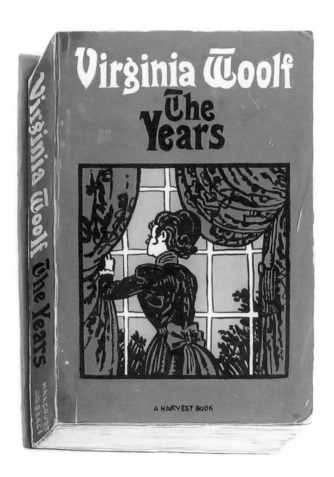

The Years, 2008
Gouache on watercolor paper, 12 × 10.5 inches

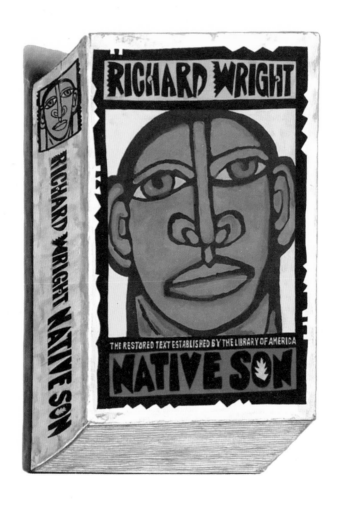

Native Son, 2020
Gouache on watercolor paper, 12 × 10.5 inches

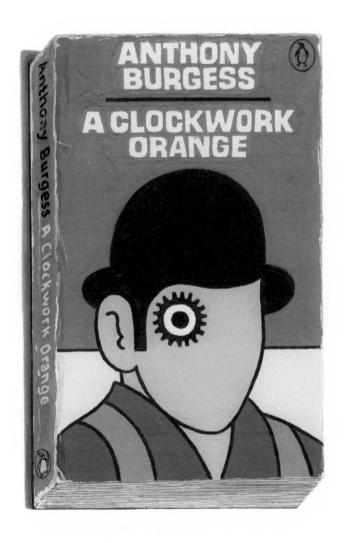

A Clockwork Orange, 2012
Gouache on watercolor paper, 12 × 10.5 inches

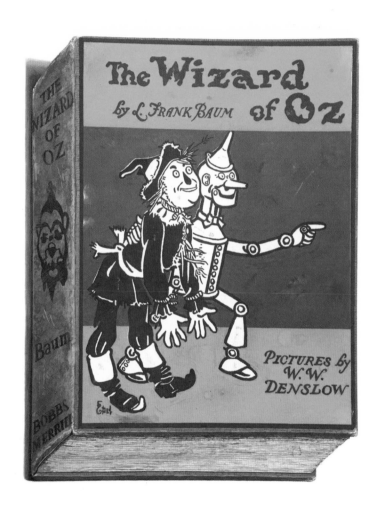

The Wizard of Oz, 2019
Gouache on watercolor paper, 12 × 10.5 inches

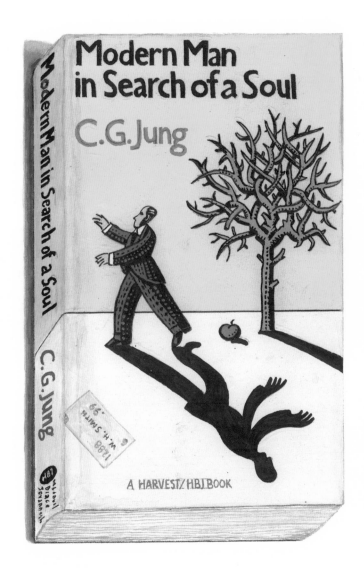

Modern Man in Search of a Soul, 2015
Gouache on watercolor paper, 12 × 10.5 inches

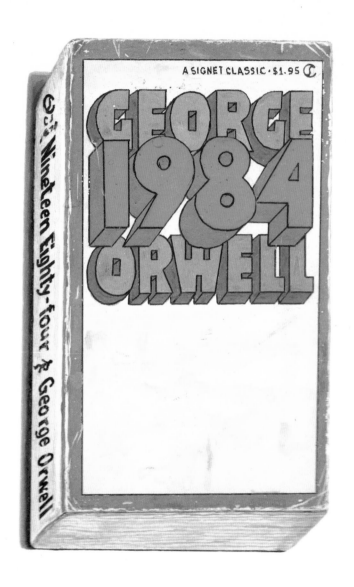

1984, 2017
Gouache on watercolor paper, 12 × 10.5 inches

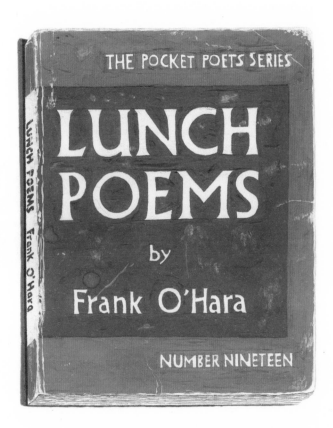

Lunch Poems, 2012
Gouache on watercolor paper, 12 × 10.5 inches

THE POCKET POETS SERIES

HOWL

AND OTHER POEMS

ALLEN GINSBERG

Introduction by

William Carlos Williams

NUMBER FOUR

Howl and Other Poems, 2012
Gouache on watercolor paper, 12 × 10.5 inches

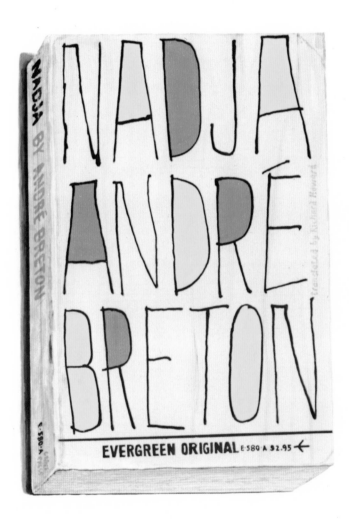

Nadja, 2012
Gouache on watercolor paper, 12 × 10.5 inches

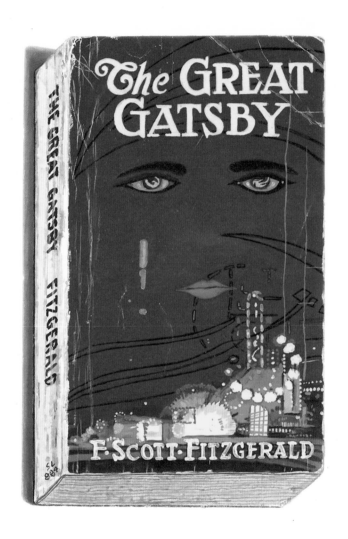

The Great Gatsby, 2012
Gouache on watercolor paper, 12 × 10.5 inches

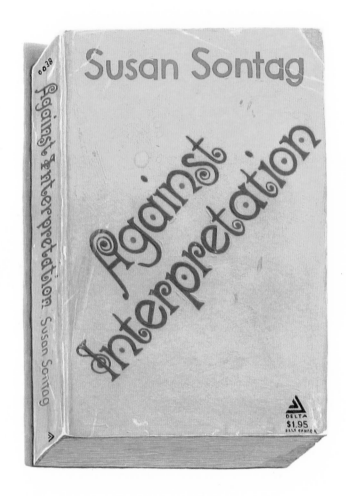

Against Interpretation, 2010
Gouache on watercolor paper, 12 × 10.5 inches

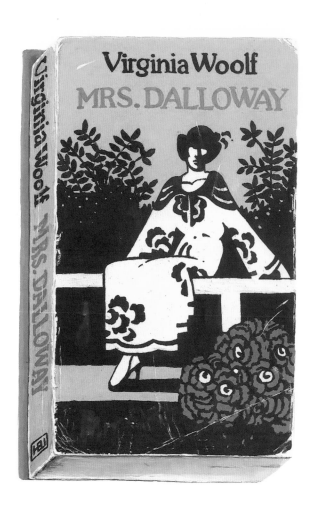

Mrs. Dalloway, 2008
Gouache on watercolor paper, 12 × 10.5 inches

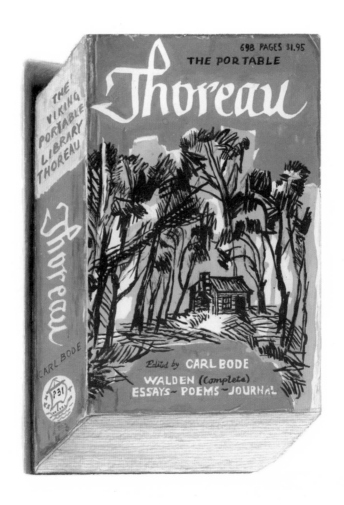

The Portable Thoreau, 2011
Gouache on watercolor paper, 12 × 10.5 inches

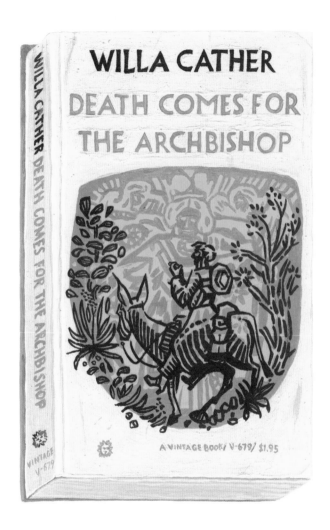

Death Comes for the Archbishop, 2008
Gouache on watercolor paper, 12 × 10.5 inches

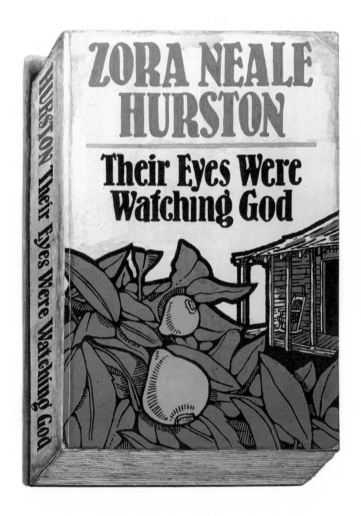

Their Eyes Were Watching God, 2020
Gouache on watercolor paper, 12 × 10.5 inches

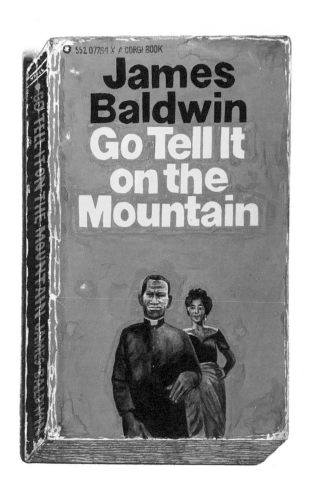

Go Tell It on the Mountain, 2020
Gouache on watercolor paper, 12 × 10.5 inches

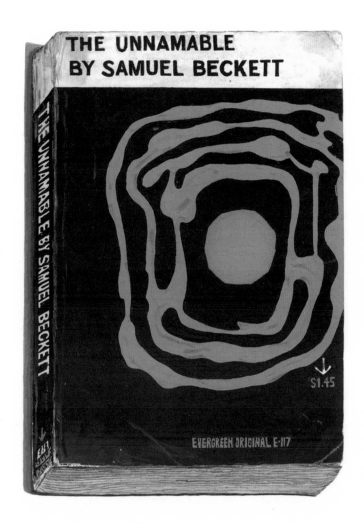

The Unnamable, 2012
Gouache on watercolor paper, 12 × 10.5 inches

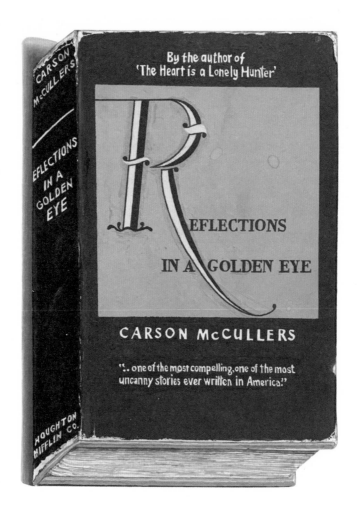

Reflections In a Golden Eye, 2020
Gouache on watercolor paper, 12 × 10.5 inches

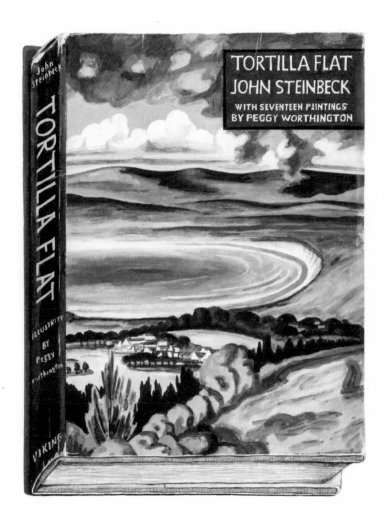

Tortilla Flat, 2012
Gouache on watercolor paper, 12 × 10.5 inches

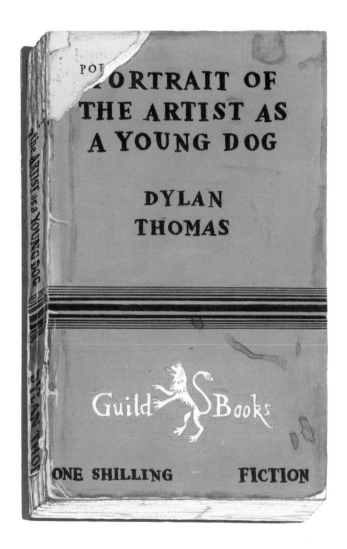

Portrait of the Artist as a Young Man, 2011
Gouache on watercolor paper, 12 × 10.5 inches

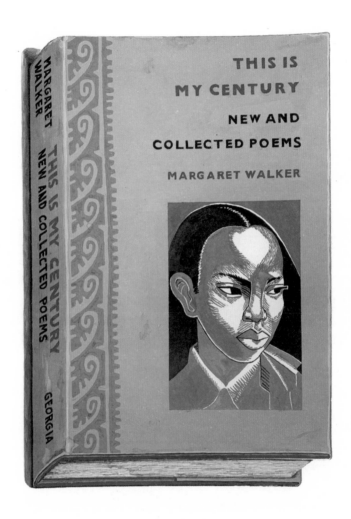

This Is My Century, 2011
Gouache on watercolor paper, 12 × 10.5 inches

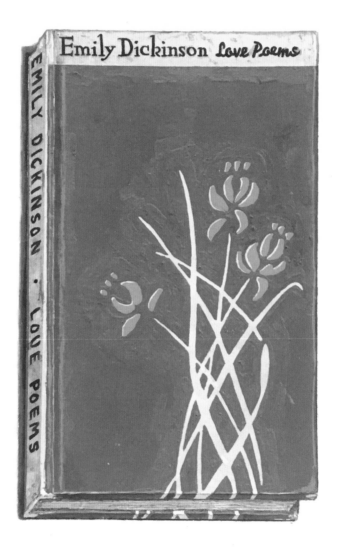

Love Poems, Emily Dickinson, 2019
Gouache on watercolor paper, 12 × 10.5 inches

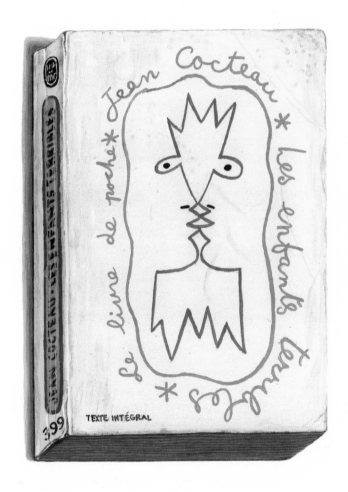

Les Enfants Terribles, 2009
Gouache on watercolor paper, 12 × 10.5 inches

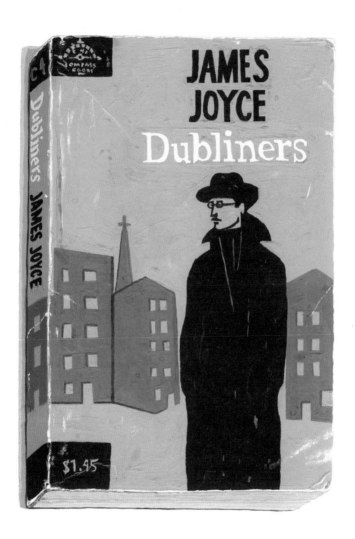

Dubliners, 2009
Gouache on watercolor paper, 12 × 10.5 inches

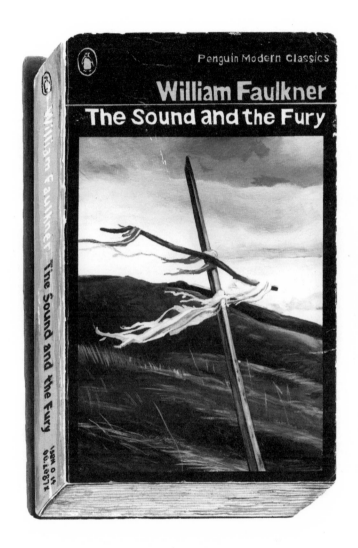

The Sound and the Fury, 2006
Gouache on watercolor paper, 12 × 10.5 inches

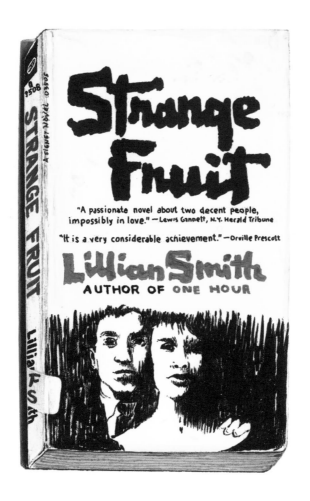

Strange Fruit, 2015
Gouache on watercolor paper, 12 × 10.5 inches

La Casa En Mango Street, 2020
Gouache on watercolor paper, 12 × 10.5 inches

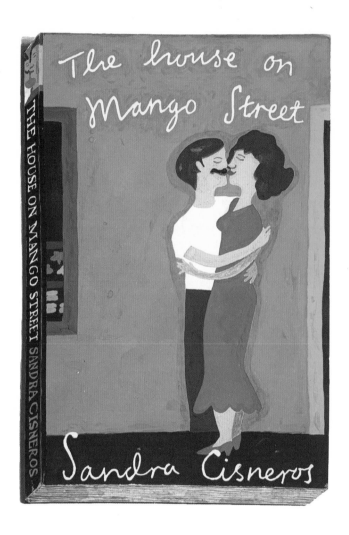

The House on Mango Street, 2019
Gouache on watercolor paper, 12 × 10.5 inches

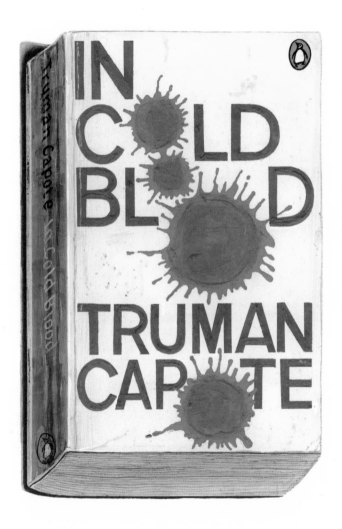

In Cold Blood, 2011
Gouache on watercolor paper, 12 × 10.5 inches

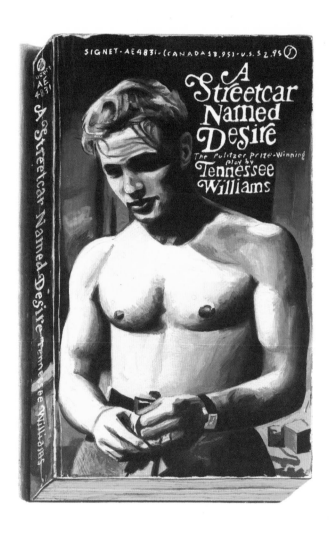

A Streetcar Named Desire, 2011
Gouache on watercolor paper, 12 × 10.5 inches

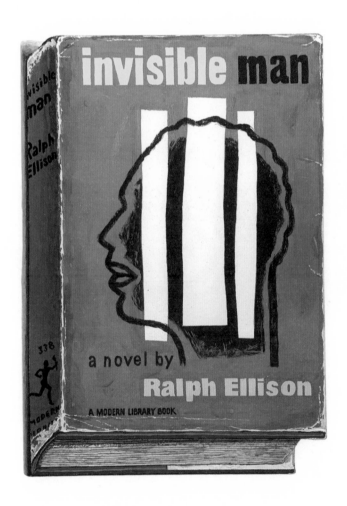

Invisible Man, 2020
Gouache on watercolor paper, 12 × 10.5 inches

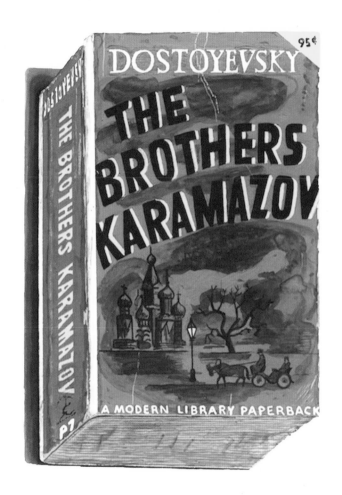

The Brothers Karamazov, 2012
Gouache on watercolor paper, 12 × 10.5 inches

BOOKS TO READ

BOOKS TO READ

BOOKS I'VE READ

BOOK GROUP NOTES

BOOK GROUP NOTES

BOOK GROUP NOTES

BOOK GROUP NOTES

BOOK GROUP NOTES

Books come to stand for various
episodes of our lives, for certain idealisms,
follies of belief, moments of love.
They accumulate our marks, our stains,
our innocent abuses—they come to
wear our experience of them on their covers
and bindings like wrinkles on our skin.

Books have always been important to me. They contain promise, optimism, and desire. They empower, ennoble, and entertain. As physical objects they are potent fetishes, icons containing every conceivable thought and emotion. We cart books on our commutes. They accompany us on vacation. We carefully pack and move them from one domicile to another, from one phase of life to the next. As our personalities are changed by books, so too do they absorb impressions of our lives. This is most especially true of the lowly paperback.[†]

I started doing gouache "portraits" of common paperbacks in 2004 after meditating on the successes and failures of R. B. Kitaj's book jacket prints from 1969. Though the images in that series have an impressive iconic quality, they do not reflect the careful marks of the artist's hand, the abuses or caresses indicative of the personal

relationship forged between the artist, the object, and the book. It was that lack that sharpened my awareness of the many complex meanings possible in a portrait of a book.

Which books to paint, then? I began to think about books that had been life changing for me, but which I now felt I could no longer return to. I wanted to move to Paris after reading Henry Miller; Louis-Ferdinand Céline spoke directly to my most disaffected adolescent angers and frustrations; Knut Hamsun mirrored my own tender love of love, mapping the consuming power of infatuation; I identified with the pointed absurdity of Alfred Jarry's *Ubu Roi* and wished to be a playwright. The list goes on. As I continued to paint books, my justifications evolved and become more various, though it remains of paramount importance that my subjects be familiar and of no special pedigree. In the end, these paintings stand against loss; for reverie, memory, optimism, desire, and love.

—*Richard Baker*

† *You may have noticed that there are a few hardcovers among the paperback books in this collection. When I first started painting portraits of book covers, I focused on paperbacks because I wanted my series to reflect an experience common to most of us. Paperbacks are affordable and portable. But as I became more familiar with the world of book design and fell in love with the work of great designers like Alvin Lustig, E. McKnight Kauffer, George Salter, and Roy Kuhlman, my series grew beyond the scope of the paperback. Equally significant, painting books drew me into direct conversation with my audience, and it became rather common for people to offer up a design gem or two from their own libraries, further diversifying my subject matter. Inclusion has been rewarding indeed!*

Richard Baker is a graduate of the School of the Museum of Fine Arts, Boston, and the Maryland Institute College of Art. He honed his craft in Provincetown, Massachusetts, exhibiting there in the late 1980s, and in New York in the early 1990s. Joan Washburn exhibited Baker's work twice in 1991 and continued to give him annual shows for the next dozen years, until he began showing with his current gallery, Tibor de Nagy. His idiosyncratic portraits open an intimate space for study and reflection. Baker continues to exhibit in New York, Provincetown, New Orleans, and Cologne.